Colour in space

Patrick Heron : public projects

Introduction

During the 1990s Patrick Heron made a number of works for public places. To date the best known is his window for Tate Gallery St Ives, completed for the new building in 1993. Others include banners for the Tate Gallery shop at Millbank, London; banners for the new Chelsea & Westminster Hospital, and a circular kneeler for the church of St Stephen Walbrook, in the City of London.

In these projects he collaborated with Julian Feary and Katharine Heron, his son-in-law and daughter who practice as Feary + Heron Architects. In the most recent work, a major urban project known as *Big Painting Sculpture* installed over the summer of 1998 in Victoria, London, he worked particularly closely with Julian Feary.

Heron grew up in a family with a serious involvement in architecture and design. His father, Tom Heron, engaged the architect Wells Coates to refurbish shops for the business he managed, Crysede Silks. When Tom Heron left and started his own company in 1930, and named it Cresta Silks, Coates designed a series of new stylish and distinctive shops for him. Heron remembered Coates giving him a Meccano construction set for Christmas in 1928, returning the compliment by coming up with a design for an imagined factory, in the style of Coates.

Despite his continuing interest in architecture and design, over the greater part of his painting career Heron made only two works for a specific architectural setting. The first was when E.C. Gregory supported his making *Horizontal Stripe Painting*, which was installed in February 1958 for the London premises of publishers Lund Humphries. The architect Trevor Dannatt was refurbishing the offices, and the work, then

termed a 'painted mural', was sized to fit a space opposite a sitting area. Dannatt designed a ceiling at two levels formed of horizontal slats, through which the upper part of the painting would be seen from a certain point, giving the painting a more dense range of colour, predominantly red, in its upper part. *Horizontal Stripe Painting* is now in the collection of the Tate Gallery, exhibited regularly both at Millbank and St Ives.

After seeing the very large 'wobbly hard-edge' painting *Cadmium with Violet, Scarlet, Emerald, Lemon and Venetian: 1969* at the Royal Academy Jubilee Exhibition of British Painting in 1977, Conal O'Sullivan, then Director and General Manager of the Cavendish Hotel in Jermyn Street, commissioned two large carpets for separate floor areas in the foyer. Heron specially designed them to be read from any angle, the conscious lack of a 'top', 'bottom' or 'sides' making them multi-directional. He made small gouache paintings, which were translated and woven by specialist woollen carpet makers in Galway. These carpets were later removed, and have not survived intact.

This publication records the 1990s projects, including the window for Tate Gallery St Ives and *Big Painting Sculpture* in London. It gives an account of the collaborative processes of designing and making these works, with photographs of the processes showing progress from the initial design, then fabrication through to completion. It indicates how, over the last decade, these projects have become some of Heron's most striking and best-known works.

St Stephen Walbrook

Tate Gallery Shop

Chelsea & Westminster Hospital

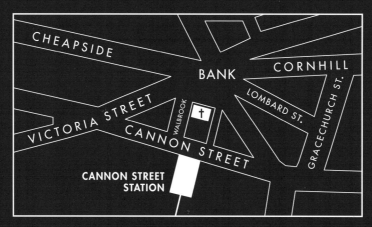

St Stephen Walbrook

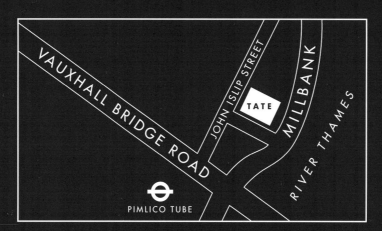

Tate Gallery, Millbank

Chelsea & Westminster Hospital

Three projects in London

The first three projects described here were made for working places in London, and can be visited during opening hours.

Patrick Heron completed two banner projects for public buildings. The first was in 1991 for the Tate Gallery Shop, refurbished by architect John Miller. Eight coloured banners each 1 metre wide by 4 metres high run the length of the spaces on either side of the central aisle, with a further banner in the entrance foyer.

The second banner project, commencing in 1992, was for the new Chelsea & Westminster Hospital. It was one of a number of artworks commissioned directly by the Hospital through the 'Arts for Health' programme. A group of three banners are hung in one of the very high atrium spaces (off the central circulation axis), overlooked by wards and treatment rooms on three sides.

In both banner projects Heron worked closely with Cathy Merrow-Smith in translating the gouache designs into fabric, and with Julian Feary who designed a structure and hanging system for the large hospital banners.

For a third project, also in 1992, Heron was commissioned to design a needle-point kneeler to surround Henry Moore's altar at St Stephen Walbrook, Christopher Wren's celebrated centrally planned church in the City of London.

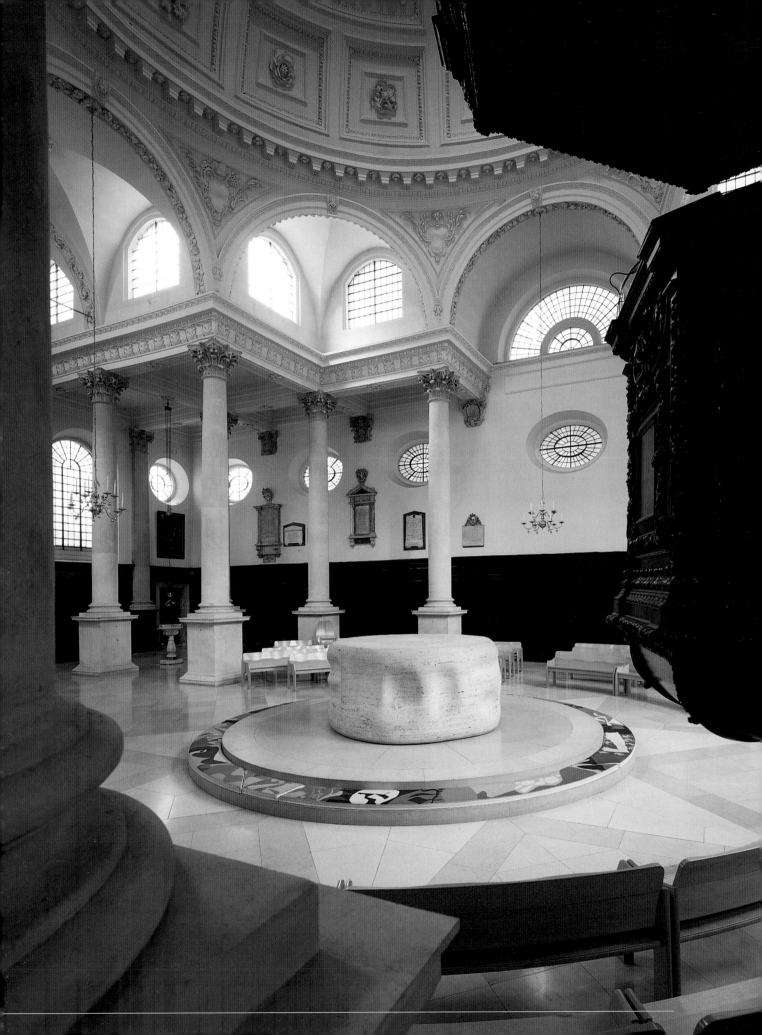

St Stephen Walbrook

Heron was commissioned to make a kneeler for St Stephen Walbrook by Lord and Lady Palumbo, who led the restoration of the church and the siting of new artworks within it. Prominent among these is Henry Moore's carved carrara marble altarpiece. Heron's kneeler was made by the Tapisserie Company in needlepoint embroidery. Church suppliers J Whippell & Co formed the embroidery into a curved kneeler, designed in irregular segments to make a complete circle around the altar. Heron's original design took into account the curved form, and following many small-scale studies the design was worked out on a full-size paper template on the floor of his St Ives studio. Many wool samples were considered, and a coded diagram was made identifying each wool colour area and given to the embroiderers for them to translate. The kneeler forms a halo of Heron's vividly coloured shapes around the altar stone, making a dramatic contrast to the monochromatic church interior of pale stone, white plaster, beech pews and dark-stained oak.

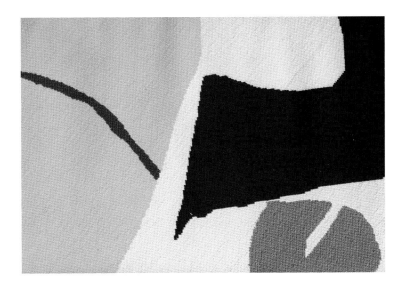

opposite: Patrick Heron's coloured kneeler encircles Henry Moore's altar

Tate Gallery Shop

In devising the Tate Gallery Shop scheme, Heron worked with fabric artist and embroiderer Cathy Merrow-Smith, making a series of small-scale silk maquettes. To translate these into banners Cathy Merrow-Smith ingeniously scaled up the studies by gridding and collaging together photocopied enlargements. Heron then worked with her to choose the final colours, relating these to his ideas for the spatial impact of the eight banners hanging as a group within the bookshop space. The single banner to be hung separately in the bookshop entrance was treated differently. Here the forms are more complex, reacting to a different architecture, with more coloured shapes on a white silk ground.

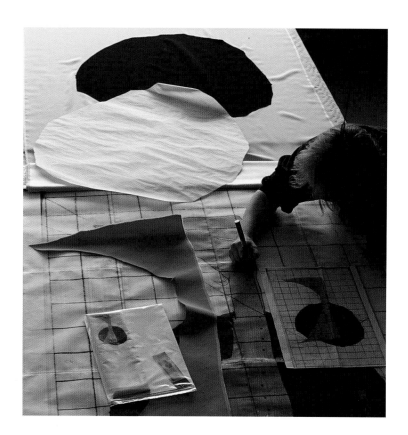

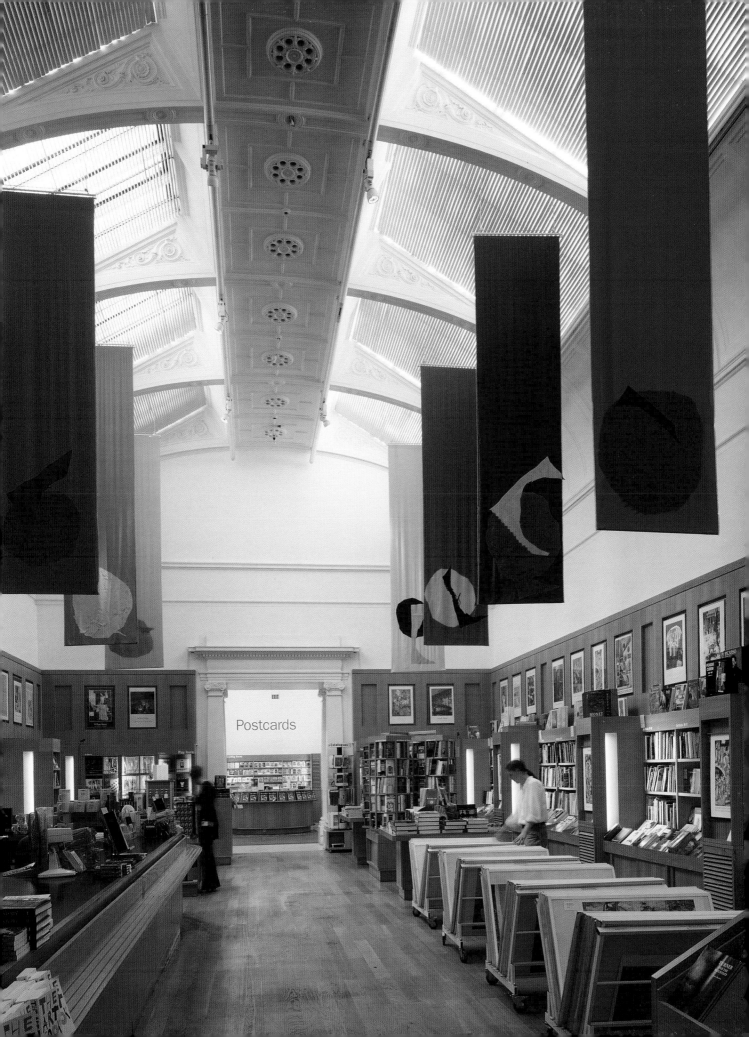

Postcards

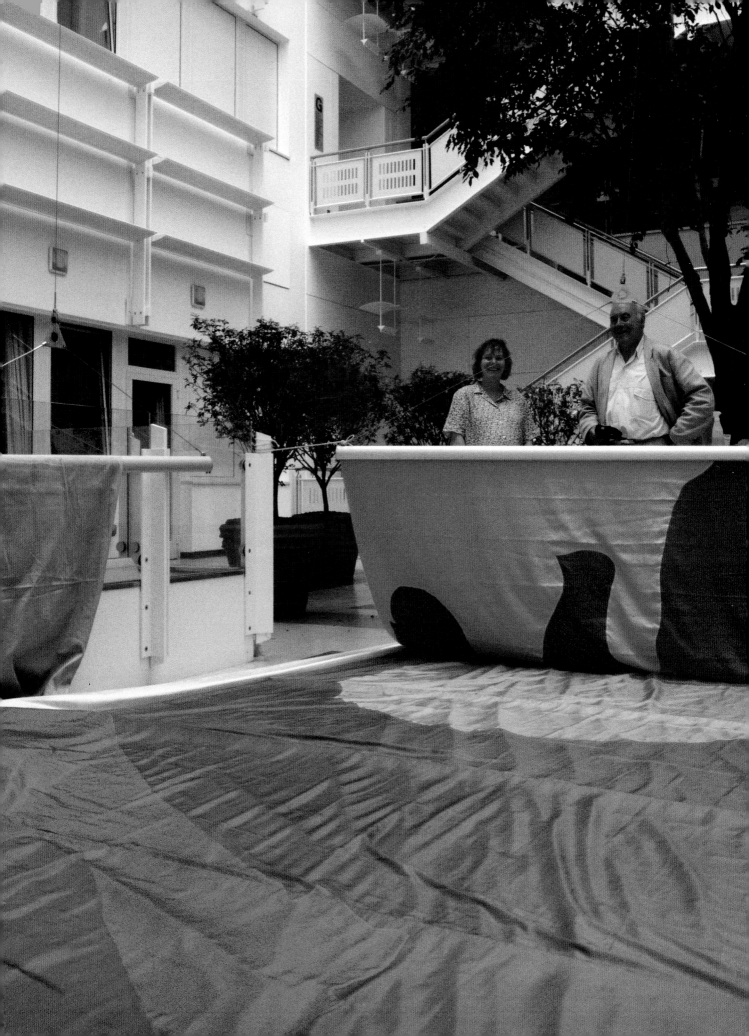

Chelsea & Westminster Hospital

Heron's banners for Chelsea & Westminster Hospital are on a very much larger scale than the Tate Shop project. Three huge coloured lengths are hung from the atrium roof structure, allowed to move and sway in a large, active and airy space. The largest banner is twenty metres in length, and the space is eight storeys high. Here again Heron worked with Cathy Merrow-Smith to make silk banners, but this time derived from small gouache studies. Cathy Merrow-Smith scaled up Heron's tiny studies by collaging together enlargements, laboriously photocopied many times, to reach the desired size. Julian Feary designed a way of stiffening the very large areas of these silk banners so that they maintained their shape while billowing in the air currents. He also designed hanging assemblies made from yachting components to carry the banners, supported from the atrium roof structure above. This allows them to revolve so that their relative positions are always changing, enlivening the view from the surrounding wards.

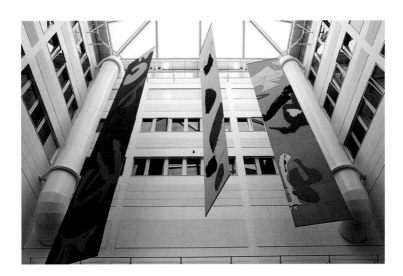

opposite: Patrick Heron and Cathy Merrow-Smith
with the largest banner ready to be hoisted into position

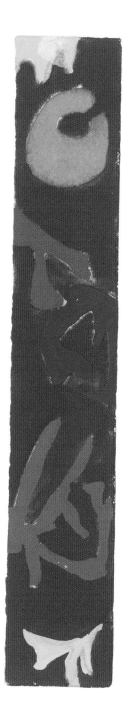
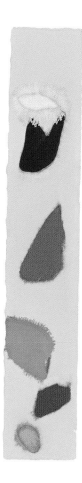

Patrick Heron's gouache studies for the Chelsea & Westminster Hospital banners

Tate Gallery St Ives

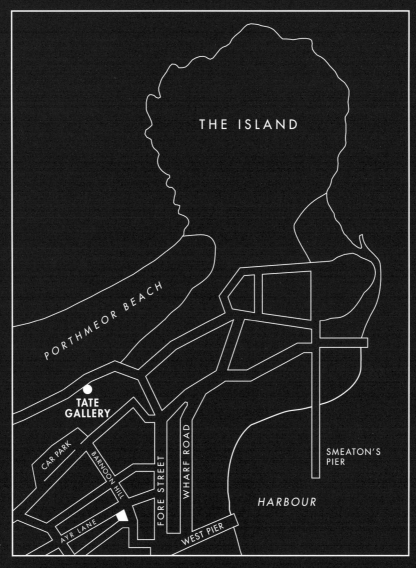

THE ISLAND

PORTHMEOR BEACH

TATE
GALLERY

CAR PARK

BARNOON HILL

FORE STREET

WHARF ROAD

AYR LANE

WEST PIER

SMEATON'S
PIER

HARBOUR

St Ives

Tate Gallery St Ives

The architects of the new Tate Gallery St Ives, Evans and Shalev, asked Patrick Heron to devise a coloured glass window for the new building. The costs were supported by the Friends of the Tate, and it was installed in March 1993.

The artist and Feary + Heron Architects worked with glass studio Wilhelm Derix GmbH & Co of Taunusstein, near Frankfurt in Germany. The window is 4.6 metres by 4 metres facing into the mall space, and is made using coloured antique glass sheets laminated onto two large panels of thick clear plate glass.

The design was translated into glass in Derix's studios. Heron's principal technical stipulation was that there should be none of the leading normally used in coloured glass windows. This stemmed from his requirement for the window to follow a fundamental idea in his work: the exploration of how areas of colour respond in juxtaposition one to another. The introduction of a black leading line at the point of contact would nullify this. The window is actually the largest unleaded coloured glass window of its kind in the world. A further requirement was for the gridded proportional system to be neither symmetrical nor central within the window rectangle.

Heron's design, like his projects in silk and embroidery, was first conceived in a small 'to-scale' gouache study. This work, painted using his favourite Japanese watercolour brushes, set out areas of colour which abutted and at points overlapped. It used flat, dense colours more characteristic of his paintings of the 1970s than the 'drawing in paint' of his contemporary studio work. The blue, green and pink-red shapes were pierced by a moment of lemon-on-white which was created in the gouache by leaving an area of paper blank apart from simple dabs of the brush.

opposite: Gouache cartoon for the Tate Gallery St Ives window reproduced here at actual size

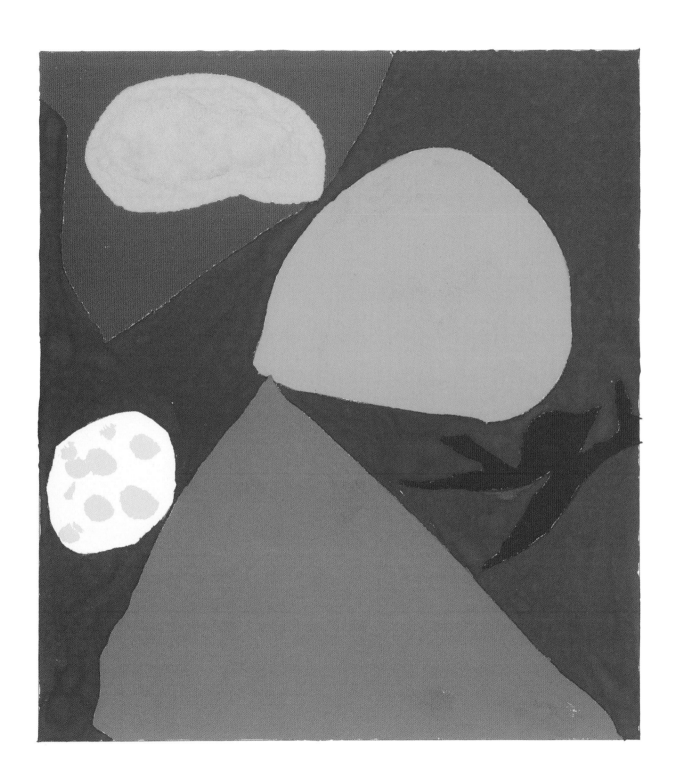

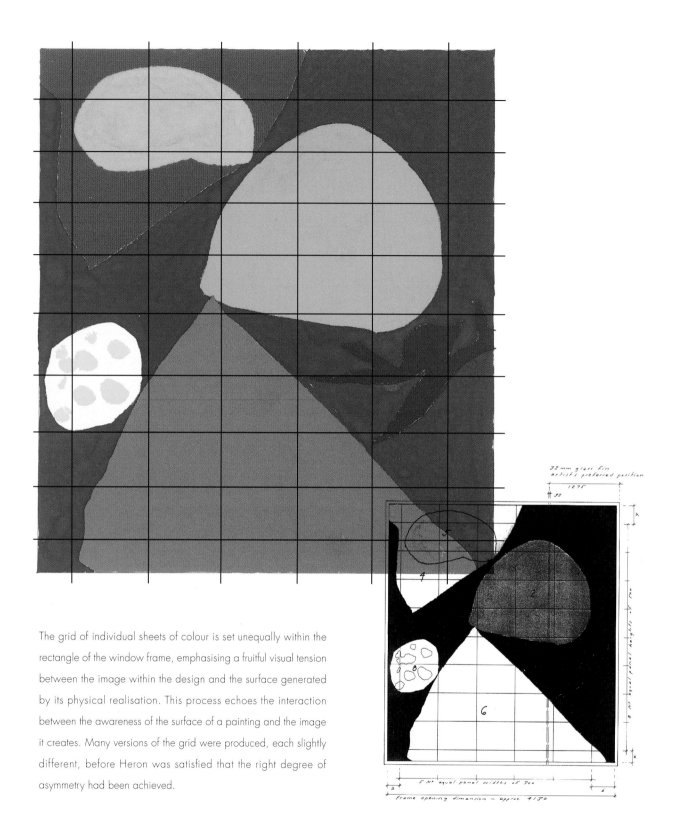

The grid of individual sheets of colour is set unequally within the rectangle of the window frame, emphasising a fruitful visual tension between the image within the design and the surface generated by its physical realisation. This process echoes the interaction between the awareness of the surface of a painting and the image it creates. Many versions of the grid were produced, each slightly different, before Heron was satisfied that the right degree of asymmetry had been achieved.

opposite: The single most delicate piece of antique glass, following successful cutting with a very fine bandsaw

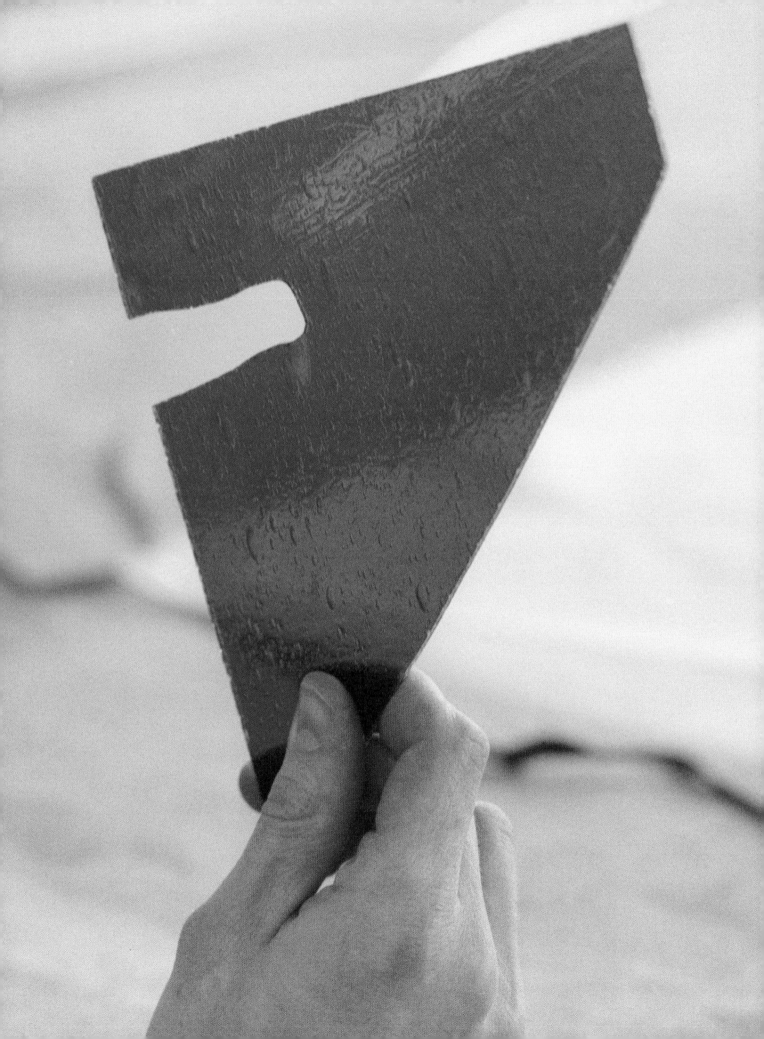

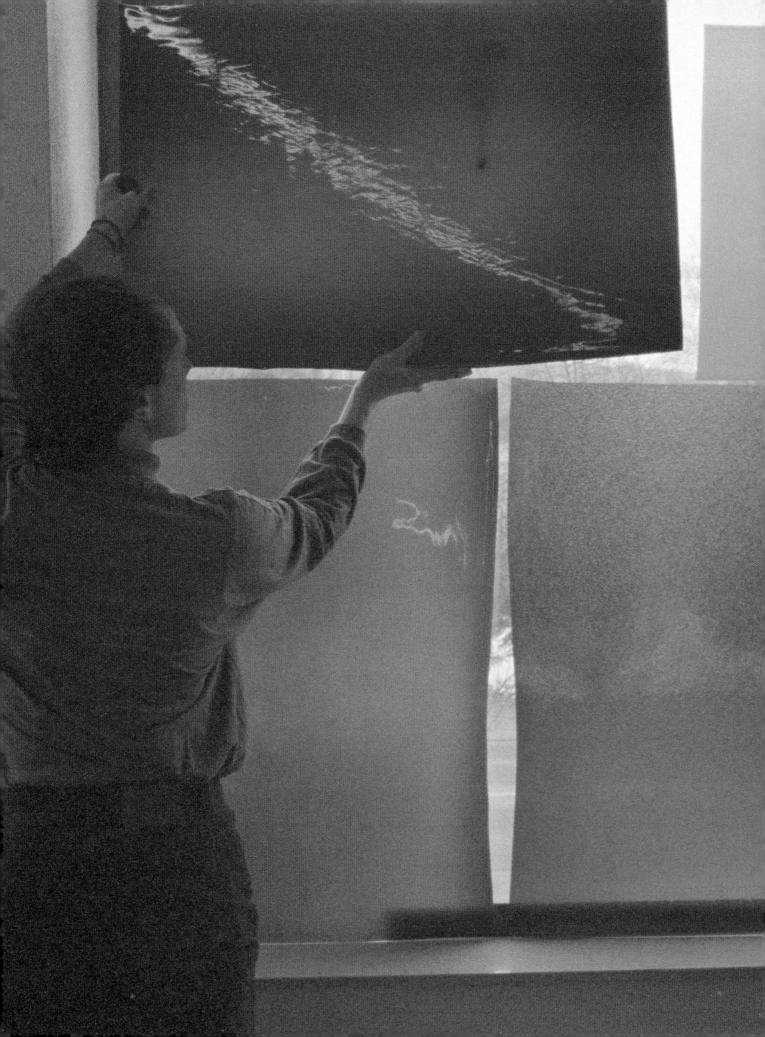

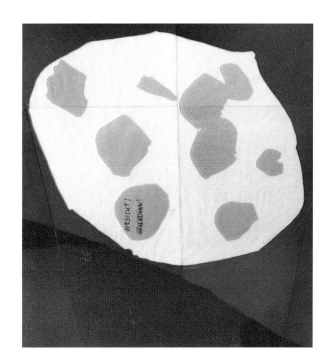

Derix proposed the technique of laminating small sheets of antique coloured glass onto two large sheets of float glass using a process they had developed. In response to the gouache they sent a series of small coloured glass samples to Cornwall, illustrating the range of colour possibilities. Heron travelled with Julian Feary to the Derix workshop to select the colours from sheets of hand-made rolled glass from Derix's 'library' of examples. Derix demonstrated their specialist processes, including the technique of making the lemon-on-white area by etching the colour out of a sheet of yellow glass. As no two hand-made sheets of antique glass are exactly alike, with differing colours, opacities and textures within each sheet, Heron examined numerous examples, comparing the variations in adjacent colour areas before making his final selection.

opposite: Different combinations of antique glass colours, as well as variations in individual sheets of the same colour, were examined against a large north-facing window which acted as a giant light box

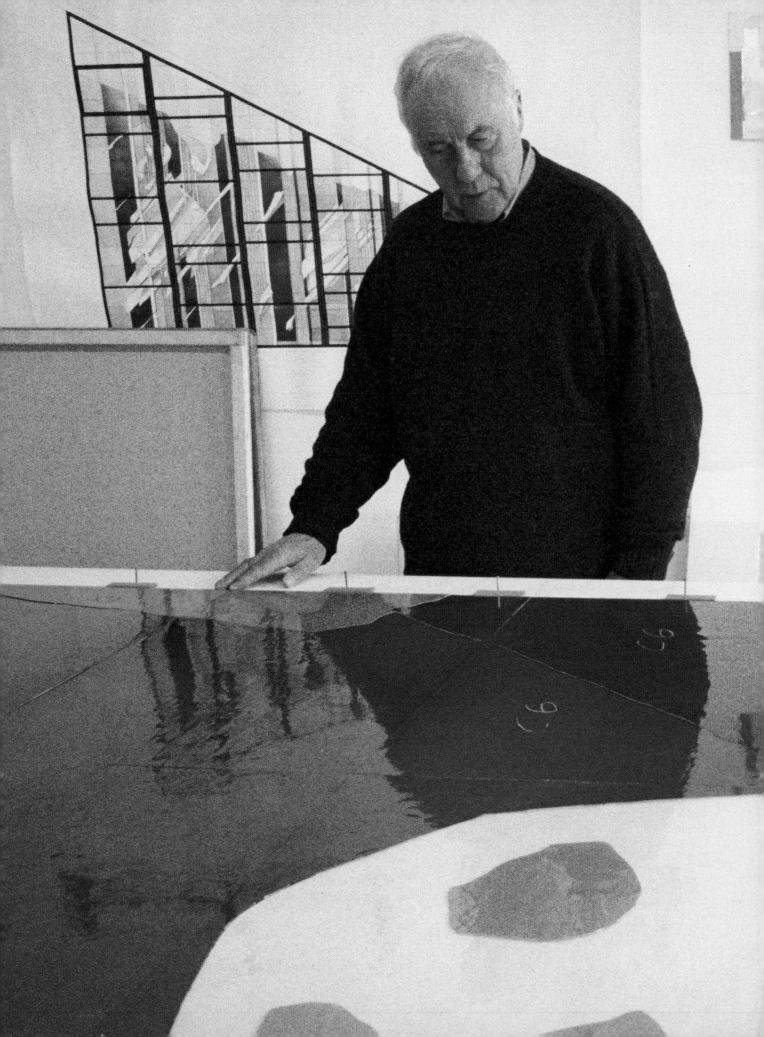

Heron commented that in working on projects such as the Tate Gallery St Ives window, the artist inevitably loses the hands-on control customary in making paintings and drawings in the studio. 'The artist', as he remarked, 'must choose when to accept what is done by others, in order to accept the outcome'. In the case of the Tate St Ives window he enjoyed the way his choice of glass gave variations within each colour area, providing slight differences in opacity and texture. The process of translating his small gouache up to scale proved more difficult, as he could not accept the quality or accuracy of their drawn line defining the colour areas. Derix's technicians had made this using the traditional method of gridding his original gouache to enlarge it by 25 times to full size. Before the glass cutting templates could be agreed he redrew their spidery line, crawling over the workshop table with a wide marker pen making a line that was both fluid and emphatic, distinctive of his hand. Following cutting of each glass sheet to the template a trial assembly was made of the whole work set out on a large table, allowing Heron to inspect and approve the transition from image to reality.

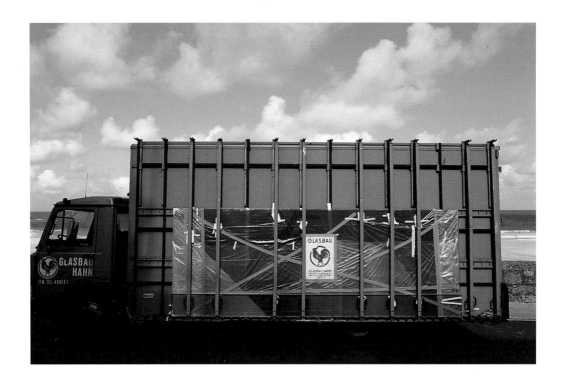

The completed sheets and a laminated 'fin' were driven from Germany to St Ives, and lifted from the lorry into position by a crane using vacuum suction pads (the round-edged rectangles on a cross-shaped unit seen in photographs). In a complex series of operations on a typically breezy morning, the large and vulnerable glass panels were carefully manoeuvred into place through a forest of scaffolding surrounding the near-complete building, immediately to be celebrated as the new gallery's first work of art.

opposite and overleaf: The large glass panels held
on the vacuum sucker pads being inched into position

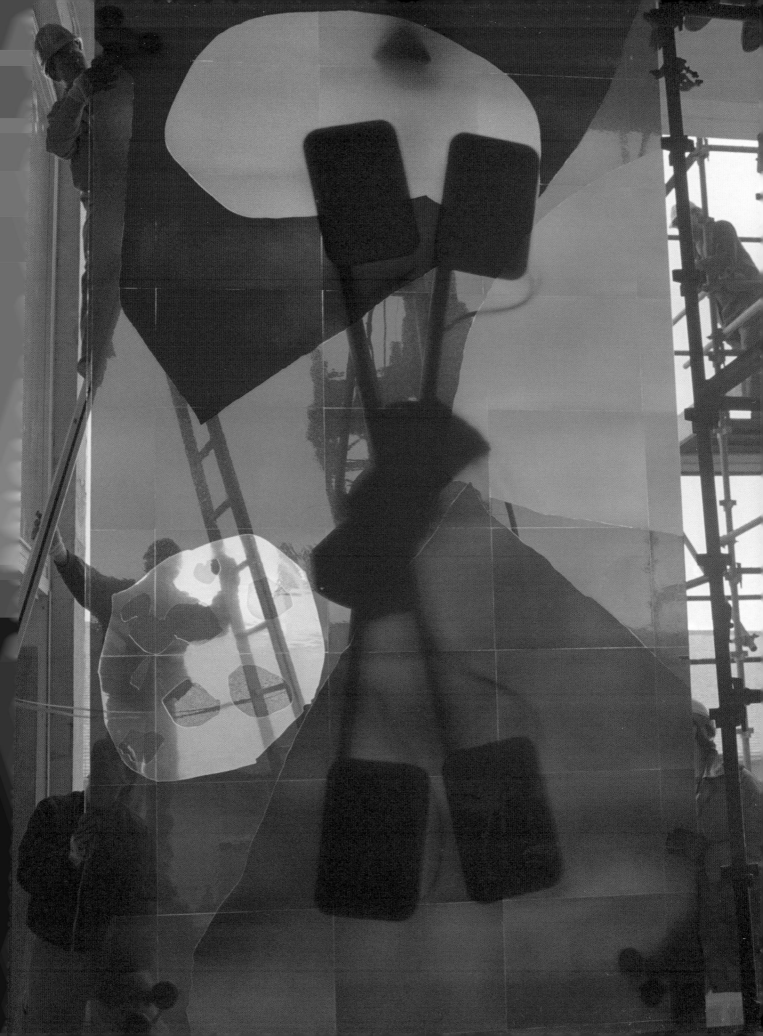

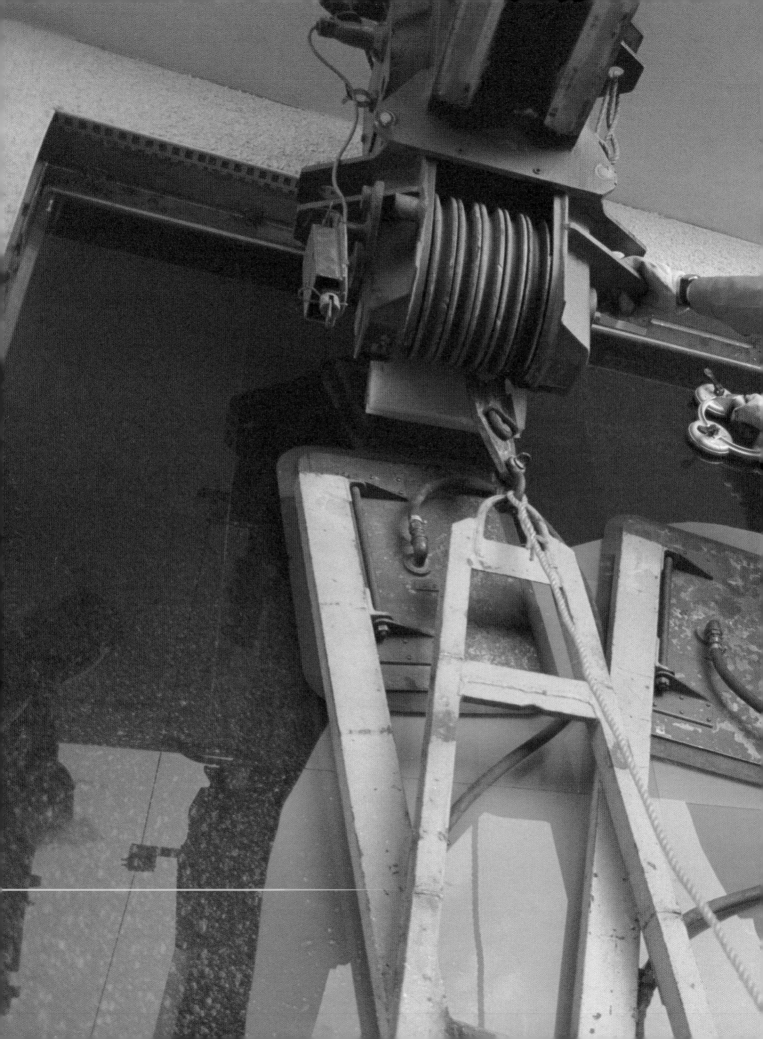

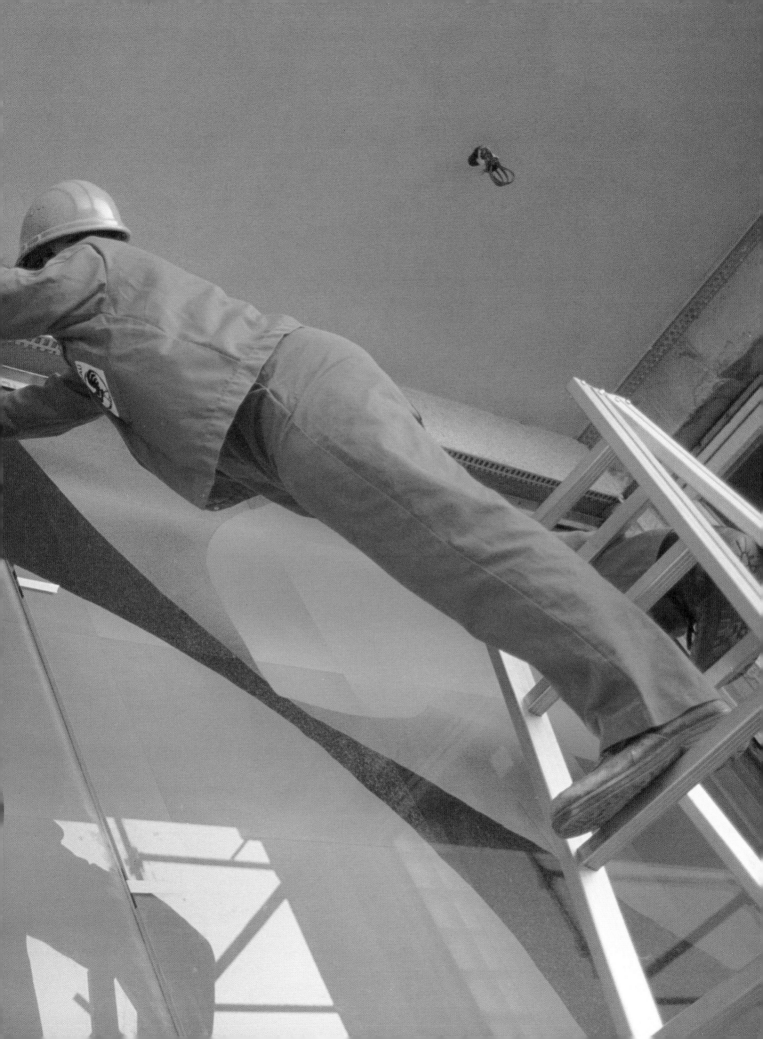

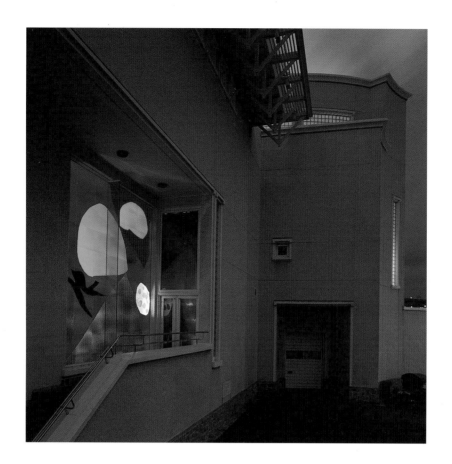

The overall dimensions of the window opening called for two large
sheets of structural backing glass, joined with a laminated glass fin
on the external face at this junction, providing additional reinforcing
against the high winds blowing in off Porthmeor Beach. Heron's
careful positioning of this external vertical line is seen from within
the gallery as a shadow centred neither within the window opening
nor on the antique glass grid, deliberately adding to the visual
tension in the composition.

Heron gasped with delight when he found how his completed
window filled the room with a deep violet light, enriching the spatial
experience of entering the gallery in a way he had not anticipated,
and of which the flat colour of the original gouache gives no hint.

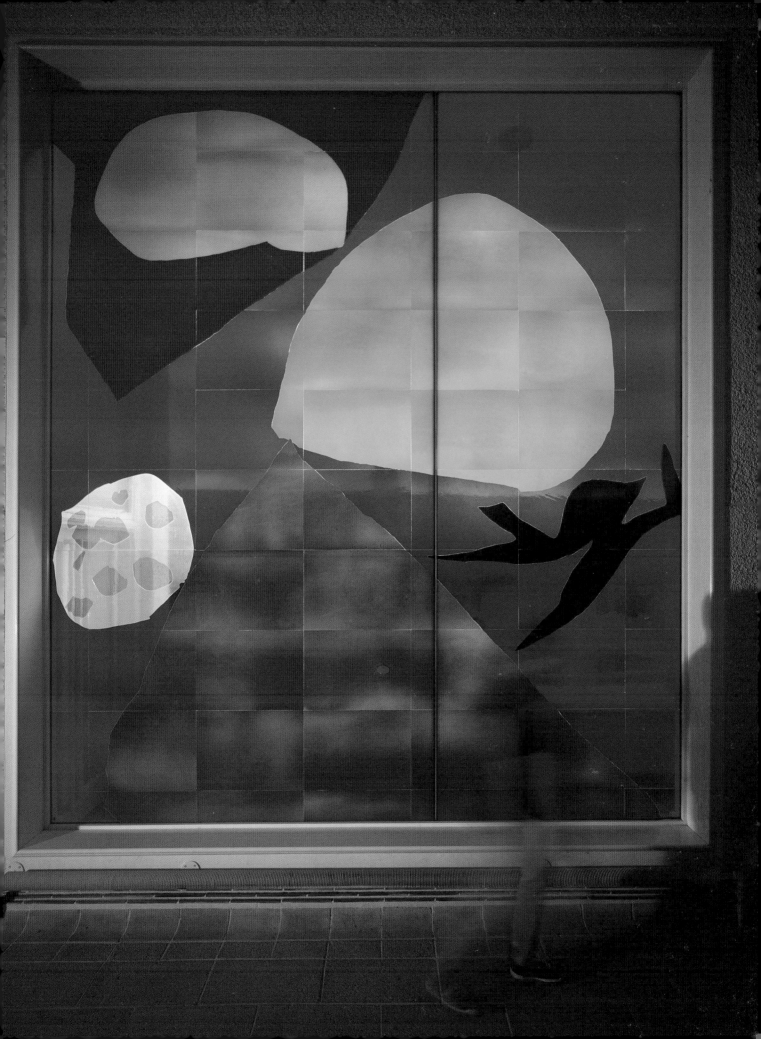

Stag Place, Victoria

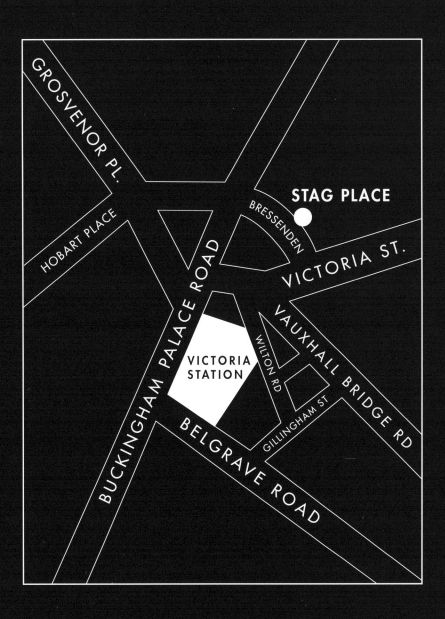

Stag Place, Victoria

Big Painting Sculpture in Stag Place is a complex, large scale, urban structure, described by Julian Feary as 'a huge and vibrantly coloured new public artwork amidst the bureaucratic greyness of Victoria'. It was made as a result of a limited competition initiated by property company Land Securities plc, to meet a Westminster City Council requirement for increased public amenity at Stag Place, a five minute walk from Victoria Station.

The competition, organised by Public Art Commissions Agency, called for a gateway into the new public piazza, created as part of Land Securities development of Eland House as the new headquarters building for the Department of Environment, Transport and the Regions. The competition brief for this gateway required it to have a strong visual presence by day and night. It also suggested that it act as a 'windscreen', providing a solution to the long standing problem of high winds at ground level generated by the shape and orientation of Portland House, the adjacent thirty-storey office building.

The winds were strongest in the area between Eland House and Portland House, and this defined the sculpture's location. Taming these wind forces determined that the engineer would also play a key role in the design of the sculpture, with its precise positioning for maximum effect. Engineering considerations fed back into the process, extending the creative possibilities that Feary was able to work up with Patrick Heron, while enforcing an overall discipline.

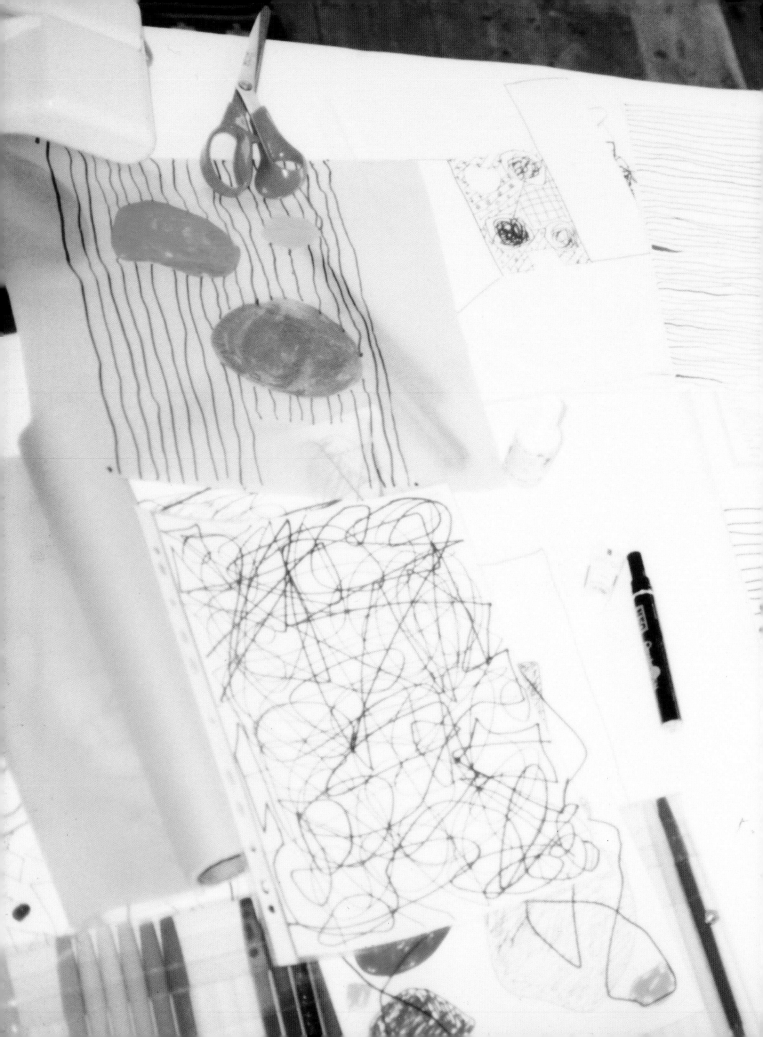

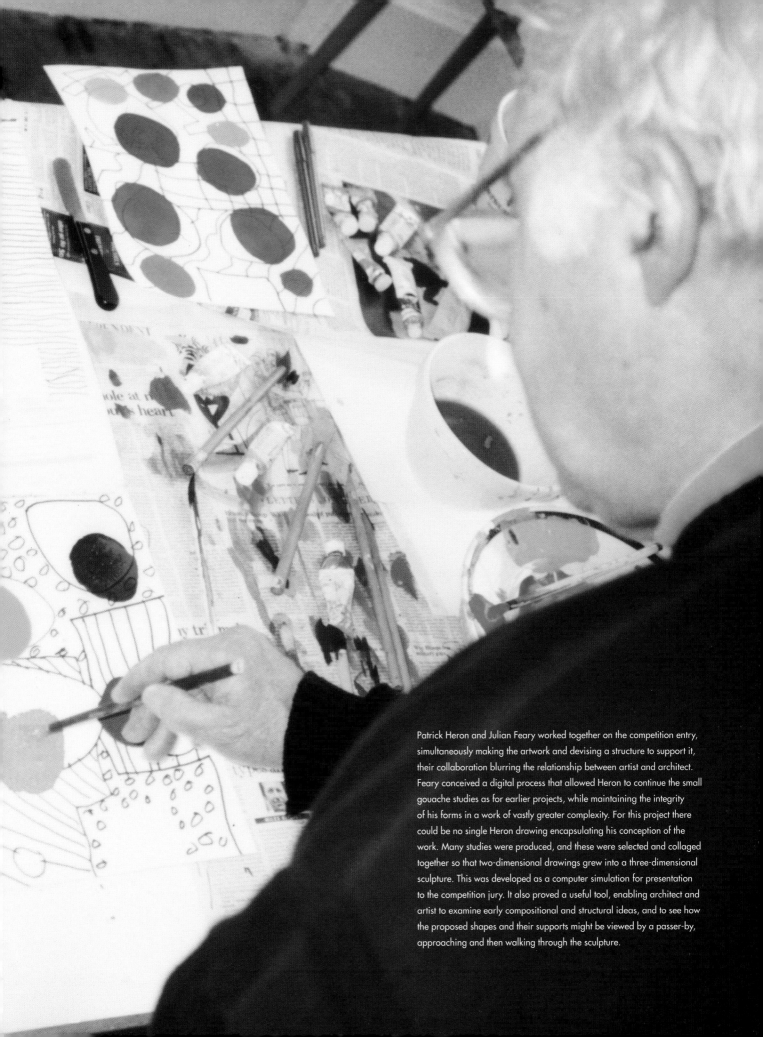

Patrick Heron and Julian Feary worked together on the competition entry, simultaneously making the artwork and devising a structure to support it, their collaboration blurring the relationship between artist and architect. Feary conceived a digital process that allowed Heron to continue the small gouache studies as for earlier projects, while maintaining the integrity of his forms in a work of vastly greater complexity. For this project there could be no single Heron drawing encapsulating his conception of the work. Many studies were produced, and these were selected and collaged together so that two-dimensional drawings grew into a three-dimensional sculpture. This was developed as a computer simulation for presentation to the competition jury. It also proved a useful tool, enabling architect and artist to examine early compositional and structural ideas, and to see how the proposed shapes and their supports might be viewed by a passer-by, approaching and then walking through the sculpture.

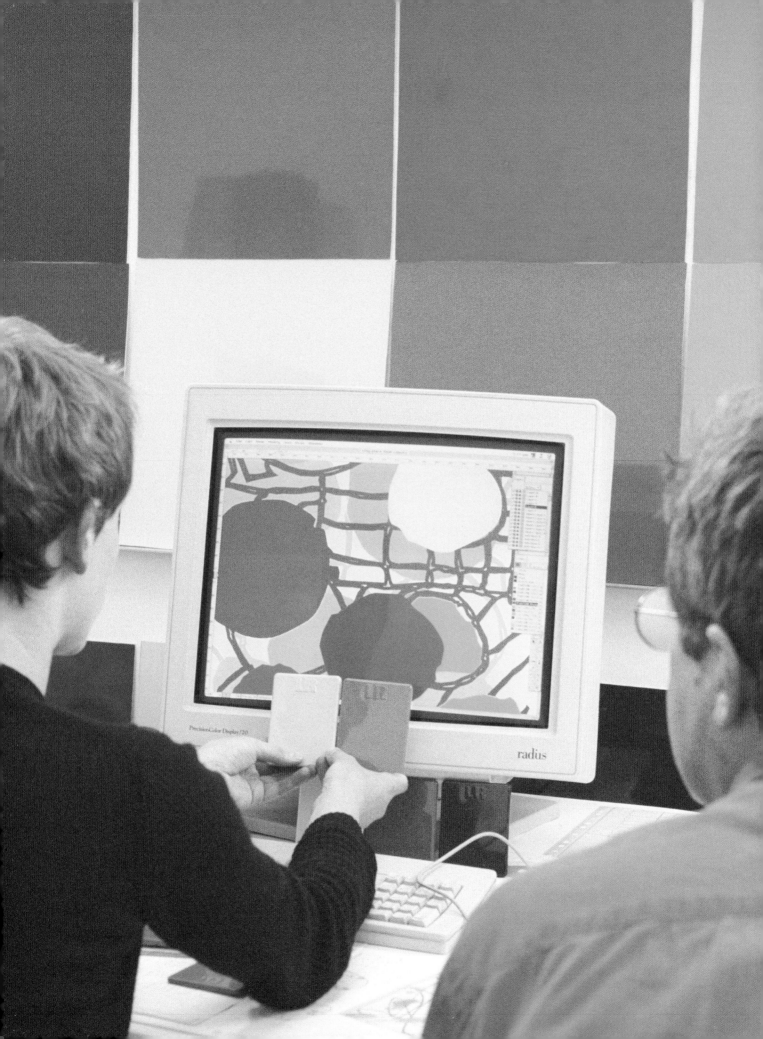

As the design developed Patrick Heron was, characteristically, both excited and uncertain. He found the digital processes used in converting his original studies into the final designs for the flat discs and lines (termed 'clouds' and 'squiggles' by the design team) very intriguing to manipulate on the computer monitors in the architect's studio. This sharpened awareness to relationships between form and colour, leading to the adoption of the principal that only the Heron shapes should be coloured, with all parts of the supporting mast structure in the 'neutral' finishes of silver anodized aluminium and stainless steel.

The computer processes enabled the Heron shapes to be precisely transferred, examined, and analysed, allowing them to be shared by architect, engineer and specialist manufacturers. The artist's lines and shapes with their hand-drawn delicacy were adopted as representations of components that could be accurately fabricated and assembled, matching the shapes in the gouache studies while having the strength to withstand the great wind forces. The principle of layers of irregular shapes enlarged precisely from the original was developed from the early conceptual studies. Detailed engineering analysis following examination in a wind tunnel revealed that a combination of layers of Heron shapes positioned in the space between the two buildings could provide a sufficiently porous barrier to the wind, breaking up the jetstreams without redirecting them past the main entrance to Eland House.

During design development the structural principles were refined, and ways of manufacturing and assembling the sculpture developed. The great problem set for architect and engineer was the need to marry a necessarily orthogonal structure with the irregularity of Heron's shapes. No clashes were permissible between the three-dimensional mesh of components that formed the structure and the irregular shapes they supported, and allowance had also to be made for the mast structure to deflect slightly under strong winds, an essential engineering requirement.

Colour, central to Heron's art, proved difficult, as the prescribed range of hues available as coloured gels for the clouds and squiggles never quite matched the palette he had envisaged. Coloured prints of the composite elevations while beautiful in themselves were never quite what was on the computer screen, while the coloured gel panels submitted as samples were different again. A solution was found when Heron prepared a chart of gouache colours straight from the tube and presented them to the colour manufacturer who devised new mixes, providing gels that were an exact match.

opposite: Work in Feary + Heron's studio searching for acceptable gels to match the chosen gouache colours as seen on the computer monitor

Six 'layers' of shapes were selected from the gouache sketches, to be laid one on another positioned on either side of the long axis of the supporting structure. Architect, engineer, contractor and artist all worked to maintain the integrity of the shapes and their relationship one to another, layer by layer, balancing this with the need for their secure attachment, keeping sufficient 'wind porosity' to avoid overloading the structure.

Changes were made to the linear elements, as these proved both too easy to climb, and difficult to support safely. Heron traced over his earlier work, redrawing many of the lines, maintaining the randomness essential to the composition, guided by Julian Feary who checked that it could be assembled within the three-dimensional grid formed by the structure.

The coloured art elements were designed as composite sandwich panels, comprising glass reinforced coloured plastic skins bonded to structural foam cores. This method of construction, introduced by engineering technology specialists Cetec, enabled each of Heron's 'clouds' and 'squiggles' to be precisely matched in shape and colour. To test their performance each individual component was subject to 'finite element' computer analysis, establishing the thickness of the panels and selecting different grades of structural foam, positioned to suit areas of varying stress.

Julian Feary worked with structural engineers Ove Arup and Partners to design an innovative structure consisting of two 19m high yacht masts combined with aluminium tubes and stainless steel rigging, forming a three-dimensional matrix of structural components acting both in tension and compression. This supports a rigid tubular aluminium spaceframe which braces the structure, and from which the 'clouds' and 'squiggles' are hung.

Five horizontal cable trusses spanning between the masts are positioned to transfer wind loadings from the large flat area of the clouds, using high- tensile yacht rigging rods arranged around each mast and fixed down to a fabricated steelwork foundation grillage set beneath the paving.

The structure is designed to be dynamic, allowing small amounts of movement at the principal junctions. This allows the entire construction to deflect slightly under extreme winds when the large flat area of the clouds generate very high horizontal forces, while avoiding problems of metal fatigue familiar in aluminium structures. Without this flexibility the structural components would have had to be much larger, becoming visually dominant and failing the engineering design brief of always maintaining the primacy of the art within overall integration.

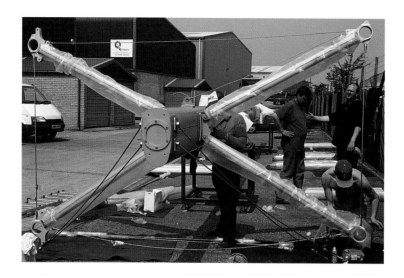

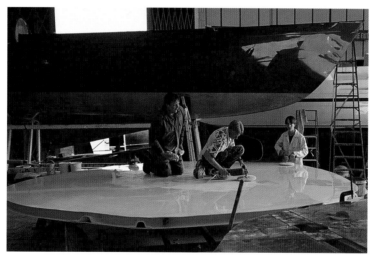

The mast structure was fabricated and pre-assembled off site by specialist metal fabricators. It was designed so that the two mast assemblies and linking truss were transported to site on three oversize trailers and lifted into position by a large crane, with the initial assembly completed over a long weekend. This operation provided the first indication of how big the sculpture would actually be, and its presence on the surrounding urban landscape.

The coloured art element composite sandwich panels and linear elements were constructed by yacht builders in Havant. They worked to full-size computer-generated templates matching each of the Heron art shapes, their maximum size governed only by the need for transport to London, passing beneath motorway bridges en route.

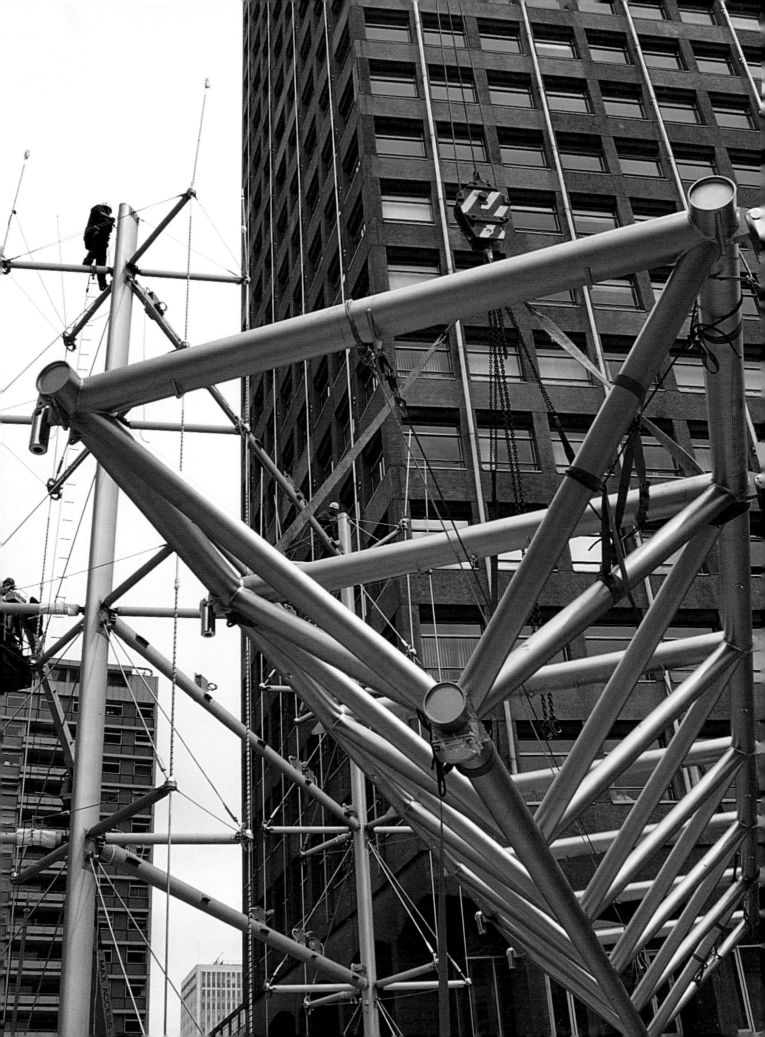

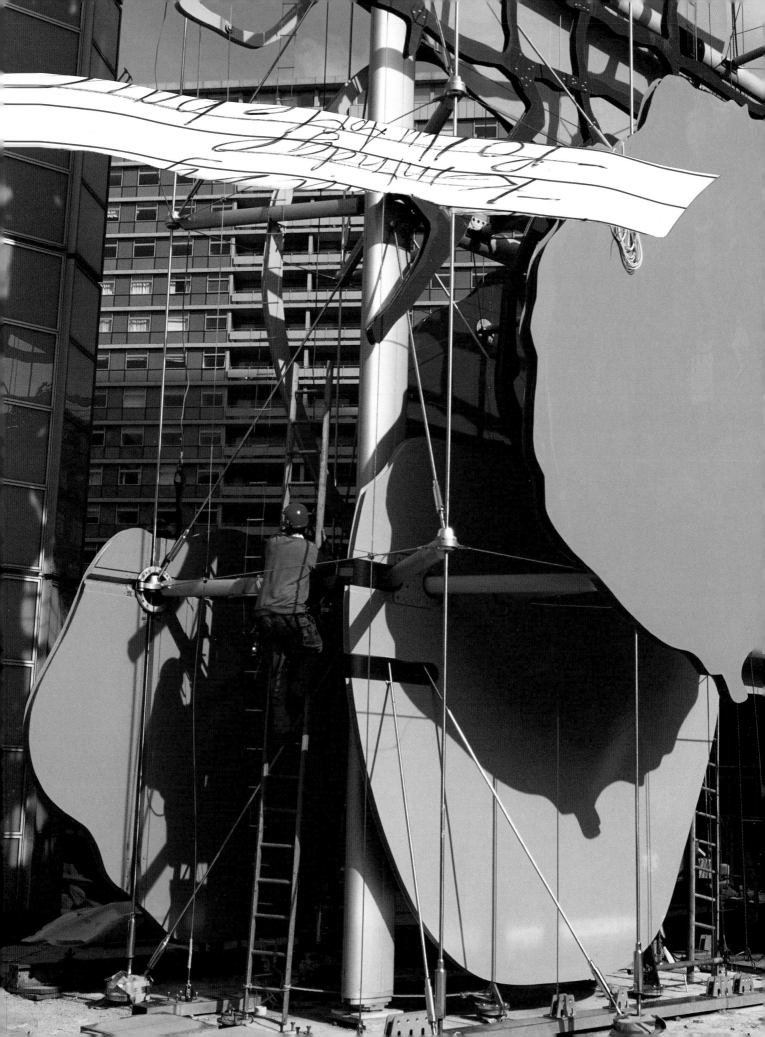

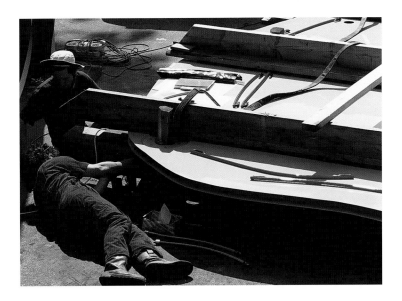

The competition brief required that the sculpture should be lit at night. Heron was worried that the colour hue would change dramatically with dusk, and under the influence of street lighting his strong and vibrant colours would lose their power. A conventional floodlighting scheme, while illuminating the external faces, would cast strong shadows within the depth of the work, countering its spatial qualities. In response Feary proposed a way of manufacturing the clouds, whose thickness would be closed around the perimeter, but set back from the actual edge. This provided a open channel, ideal to house a neon tube formed to follow the irregular perimeter outline. This idea was developed with neon artist Peter Freeman, coincidentally a Cornwall neighbour of Patrick Heron, who was able to offer a palette of neon colours that were both rich and delicate.

To examine the likely effect of the neon lighting a large-scale mock up of one of the clouds, painted a bright 'Heron' orange, was made and assembled in Feary + Heron's studio. This was fitted with yellow neon tubes, and examined during both day and night. The neon light proved to be brilliantly colourful after dark, giving the unanticipated effect of concentrating attention on the clouds glowing perimeter, rather than the daytime view of flat colour areas. This demonstrated how the sculpture could have a separate day and night presence – a requirement both artistic and practical.

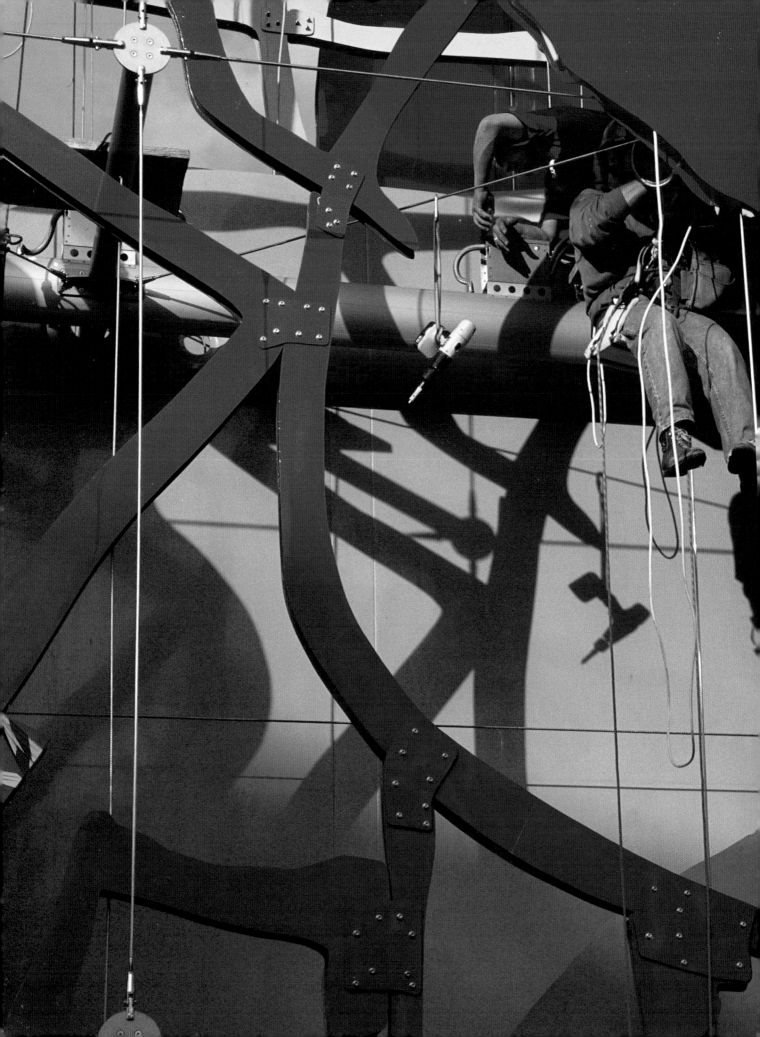

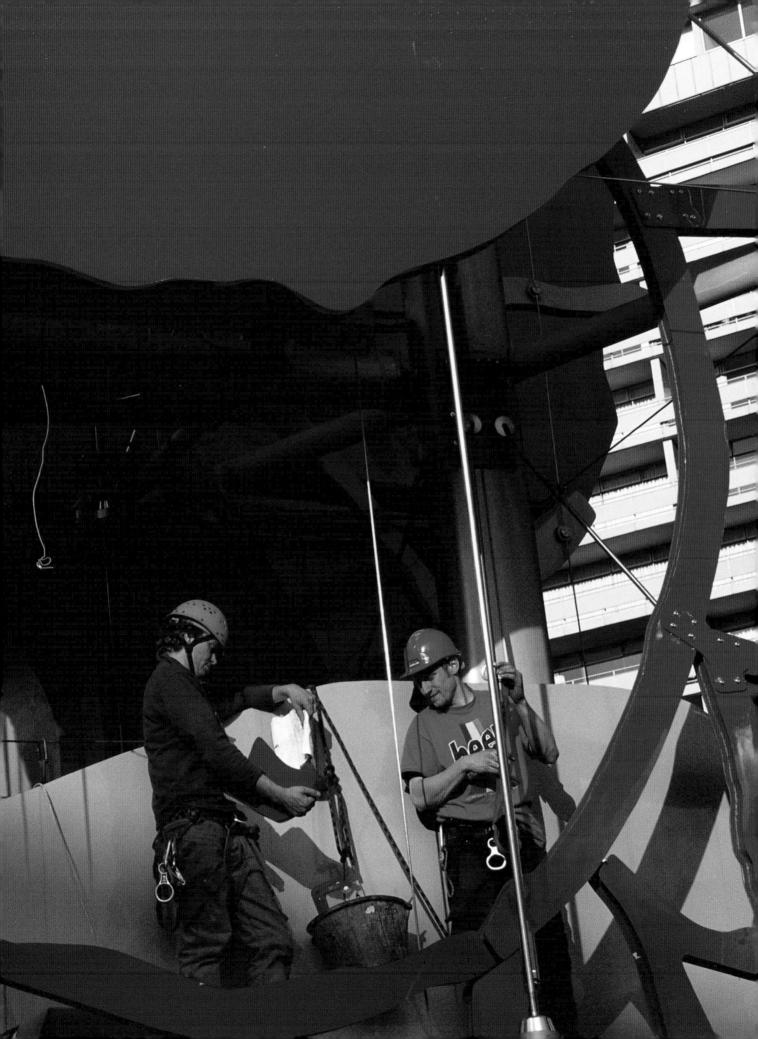

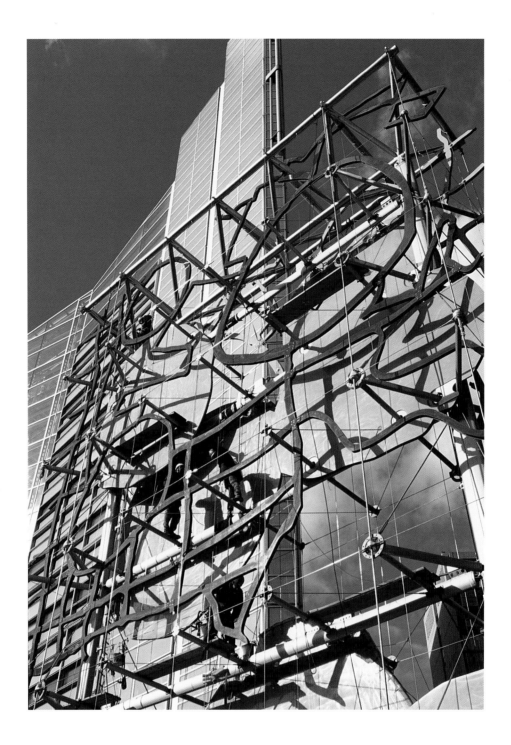

The linear 'squiggles' make two 'layers' of the sculpture. They form a continuous skein, threading through the structure. Feary divided Heron's continuous drawn line into forty-one distinctive components, each sized so that they could be manhandled during manufacture and installation. A team of riggers inserted these irregular shapes into the structure, fitting them together while simultaneously clamping them to the supporting rigging wires, working down from the truss in a precisely programmed sequence of operations.

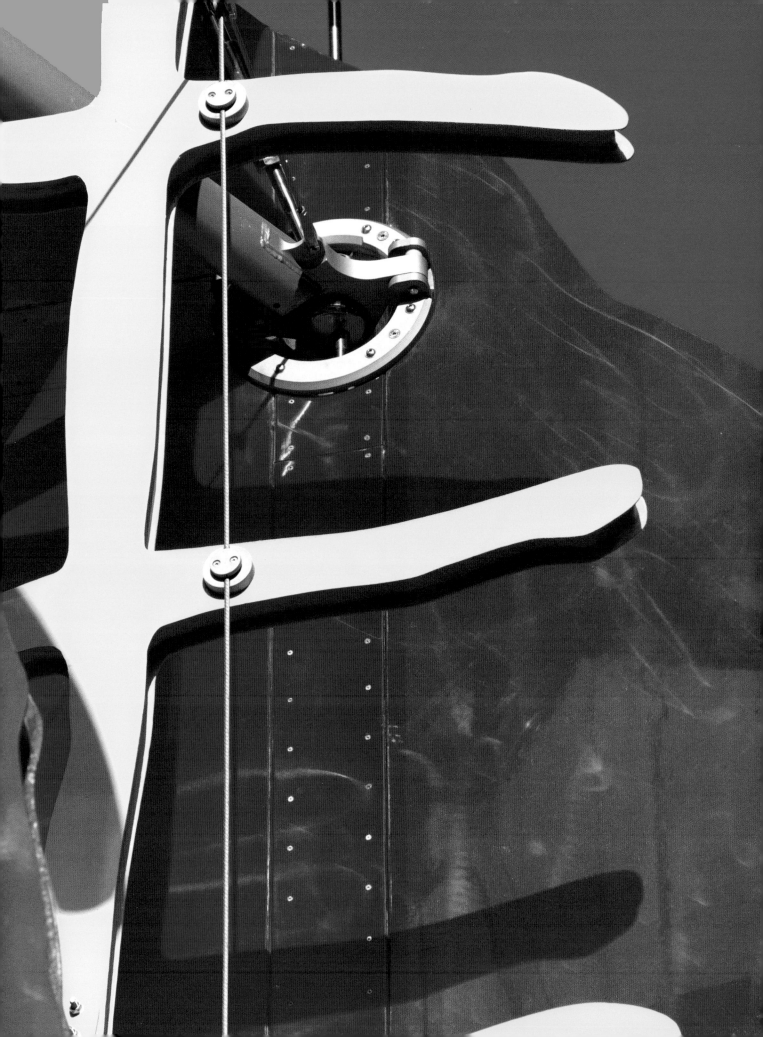

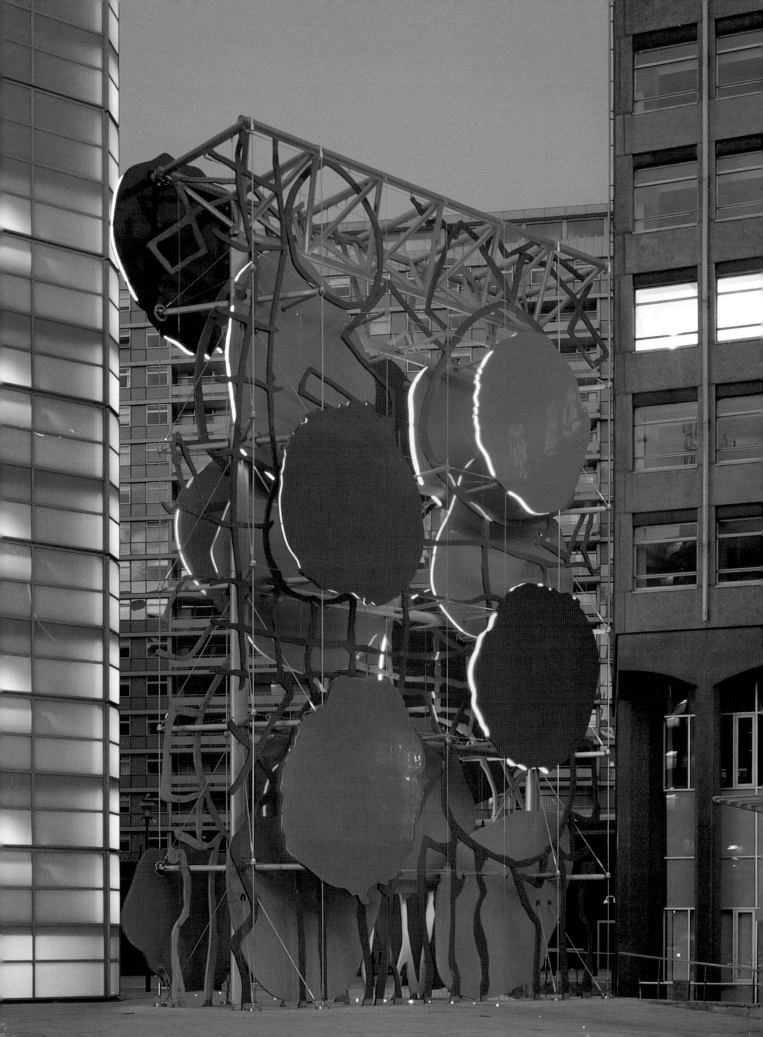

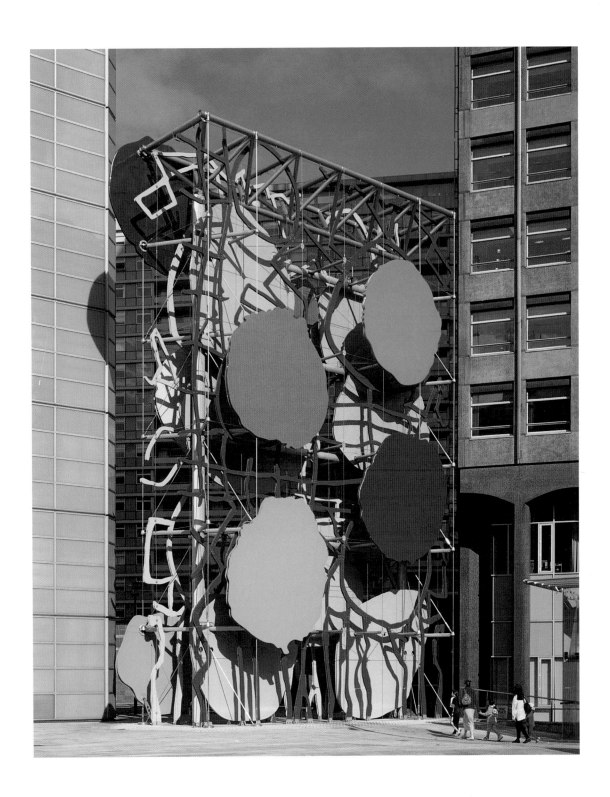

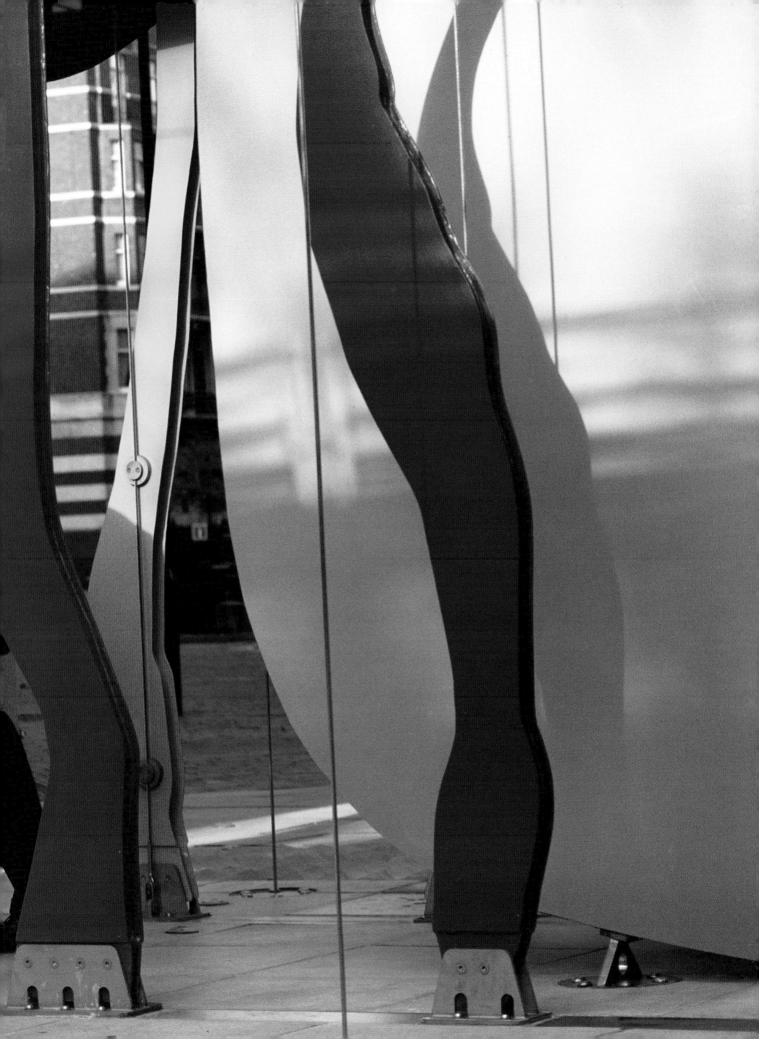

Credits

St Stephen Walbrook

Artist	Patrick Heron
Designer	Feary + Heron Architects
Client	Lord & Lady Palumbo
Needlework	Tapisserie
Manufacture	J Whippell & Company Limited

Tate Gallery Shop Banners

Artist	Patrick Heron
Architect	John Miller & Partners
Client	Tate Gallery
Manufacture	Cathy Merrow-Smith

Chelsea & Westminster Hospital Banners

Artist	Patrick Heron
Architect	Feary + Heron Architects
Commissioning Agent	Arts for Health
Hospital Consultant	James Scott MA FRCS
Manufacture	Cathy Merrow-Smith
Structure & Installation	Proctor Masts Limited

Tate Gallery St Ives Window

Artist	Patrick Heron
Designer	Feary + Heron Architects
Client	Tate Gallery St Ives / Friends of the Tate / CCC
Art Glass Specialist	Derix Glasstudios
Fabrication & Installation	Glasbau Hahn GmbH + Co KG

Big Painting Sculpture

Artist	Patrick Heron
Architect	Feary + Heron Architects
Client	Land Securities plc
Wind Engineer	Ove Arup & Partners
Structural Engineer	Ove Arup & Partners
Project Manager	Weller Associates
Main Contractor	John Mowlem & Company plc
Main Contractor Engineer	CETEC Consultancy Ltd
Neon Artist	Peter Freeman
Site Installation	Pagoda Group
Metalwork Fabrication	Devomet Ltd
Electrical Installation	Red Indian Electrical Services
Art Element Manufacture	Northshore Composites Ltd
Rigging Components	Navtec Norseman Gibb Ltd
Art Element Transport	Art Services Limited
Planning Supervisor	RT James & Partners Ltd
Competition Management	PACA

DATE DUE

Further reading

For fuller information on the artist, the following recent
publications contain biographical and bibliographical details:

Patrick Heron, retrospective exhibition catalogue,
Tate Gallery, London 1998

Painter as Critic, Patrick Heron: Selected Writings,
ed. Mel Gooding, Tate Gallery Publishing, London 1998

Patrick Heron, Mel Gooding, Phaidon, London 1994

Heron is also the subject of a forthcoming study by
Fiona MacCarthy in the Tate Gallery series 'St Ives Artists'

Acknowledgements

Publication devised by Julian Feary and Michael Tooby

All photographs © Julian Feary except: pp.8, 50, 51 © Richard Glover;
p.9 Tate Gallery; p.10 Cathy Merrow-Smith; pp.30, 31 Bob Berry
back cover; Frank Herholdt

Works by Patrick Heron © Patrick Heron Estate / DACS 1999

Text © Michael Tooby and Julian Feary, 1999
All rights reserved
Designed by Rose-Innes Associates
ISBN 1 85437 297 1

Compiled to commemorate the completion of *Big Painting Sculpture*, autumn 1998.
Publication material based on the exhibition designed by Julian Feary and Anna Hart
Colour in Space – Patrick Heron : public projects at
Tate Gallery St Ives, June – October 1998

Published by Tate Gallery St Ives
Porthmeor Beach
St Ives
Cornwall
TR26 1TG

Printed in Great Britain by BAS Printers Limited, Over Wallop, Hampshire